Emotions
Of
Color

Martin R. Boughner

Copyright © 2013 Martin R. Boughner

All rights reserved.

ISBN:149034909X
ISBN-13:9781490349091

DEDICATION

This particular work is dedicated to our children; Ryan, Kyle, Bredt and Brennan.
Your Mom and I could never achieve anything as great as you four but
with your help, love and support we can still create some great works of art.

ACKNOWLEDGMENTS

Without Elisa's great sense of color and content,
I would never be able to tell some of these stories.
Each image talks to me,
I hope dear reader,
you enjoy what they have to say.

Emotions of Color

Color inspires. Color directs.

Color holds an emotional bond for the viewer and the artist alike.

A bond played out again and again through the canvas,

the stroke of the brush and the eye of the beholder.

Color is interpreted differently be each viewer, making a bright

Van Gogh depressing or a rich Monet introspective and deep.

The subject may reveal intent of vision but color reveals the soul of the artist.

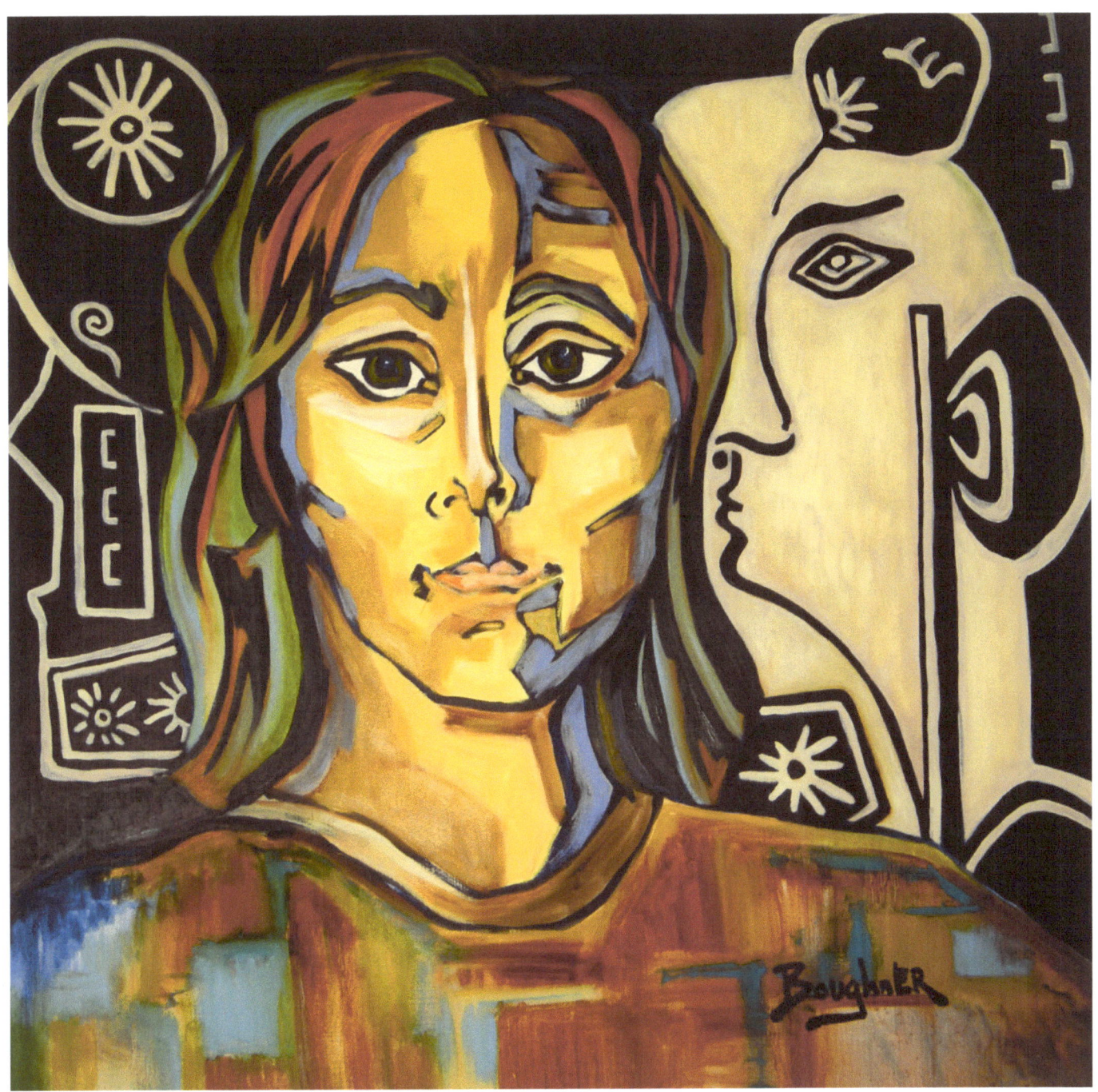

No Matter What the Day May Bring

I roll over as the light of dawn threatens to break through the blinds.

I am not trying to escape the coming day, but to start my day well.

I gaze upon the rustled heap laying next to me.

Her head nestled deep within her pillow, covers wrapped tight against the night's chill.

As always, the site of her takes my breath away, as it has for over 30 years.

My scrutiny will usually be answered by a small snore, as if to say;

"I am not worth this much attention."

But she would be mistaken in that.

My day can begin, the image of her locked firmly within my heart,

to carry with me no matter what the day may bring.

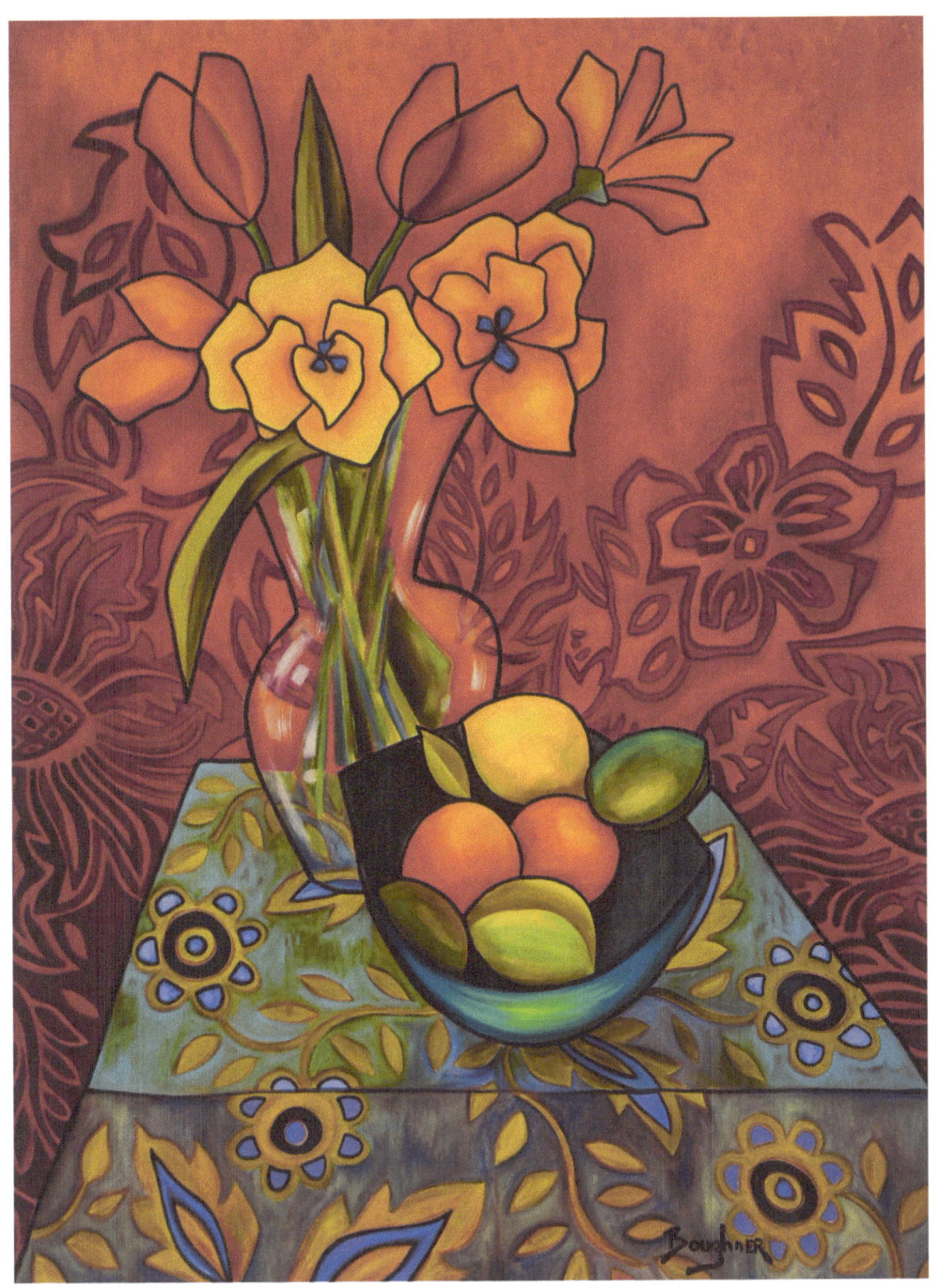

Porcelain Wonder

Her porcelain skin calls to me even now.

The soft texture of her cheek against my caress.

I wonder what she thinks of me.

The brutish beast of song and lore or the gentle prince of stories old?

For me she is the porcelain vase that sits high upon the shelf, always to be seen, but too precious to touch.

The beauty of which makes the flowers wilt with despair.

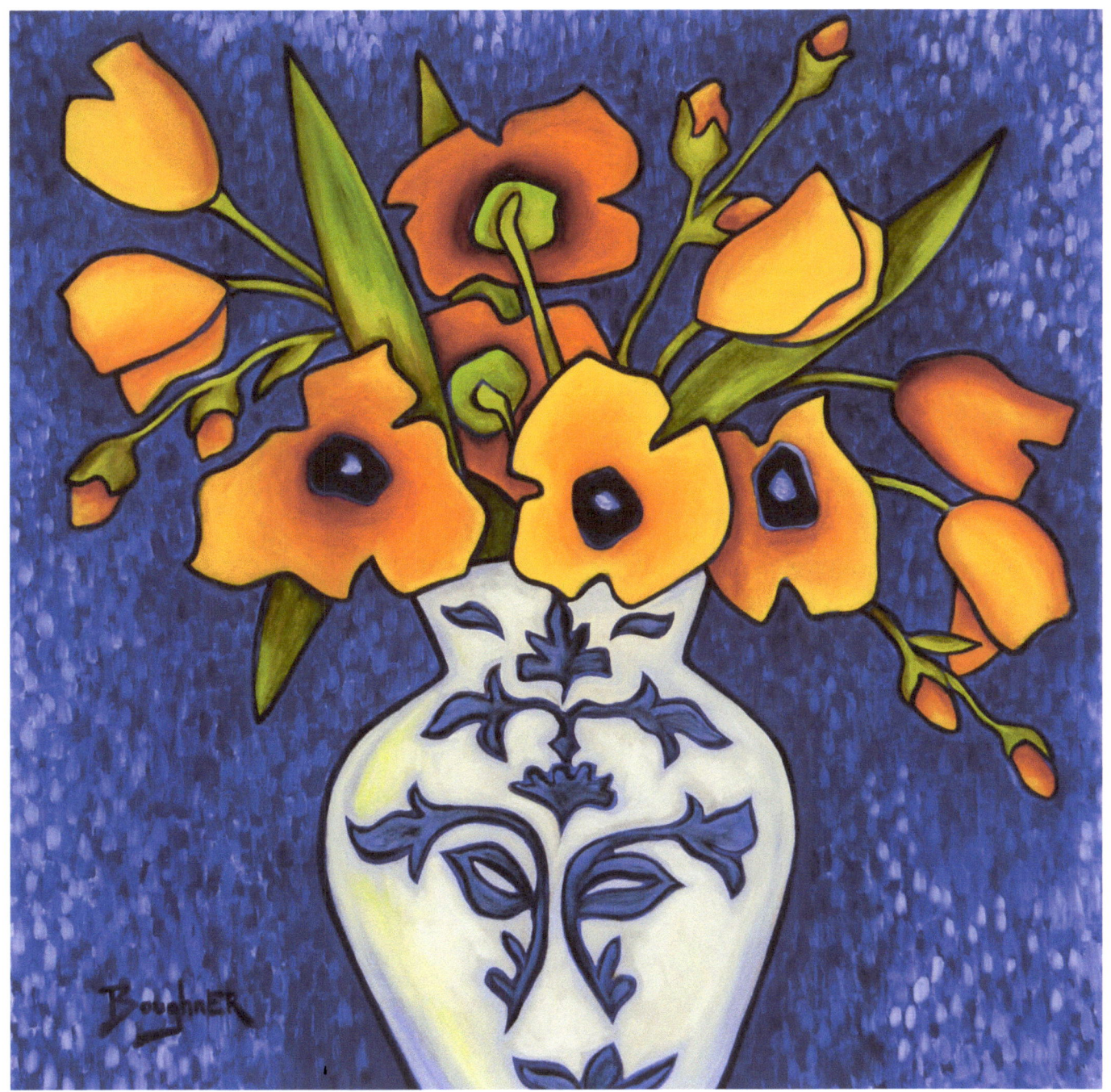

True Beauty

Her pants do not match her top.

Her socks are not the same color or pattern.

Her hair has the look of the wild about it.

All in all a very disreputable figure.

Then why is it each time I see her she makes me smile?

Filling with a warm sense of love and pride that she can present herself to the world any way she wants.

Because it is the confidence inside that really lets the true beauty shine through.

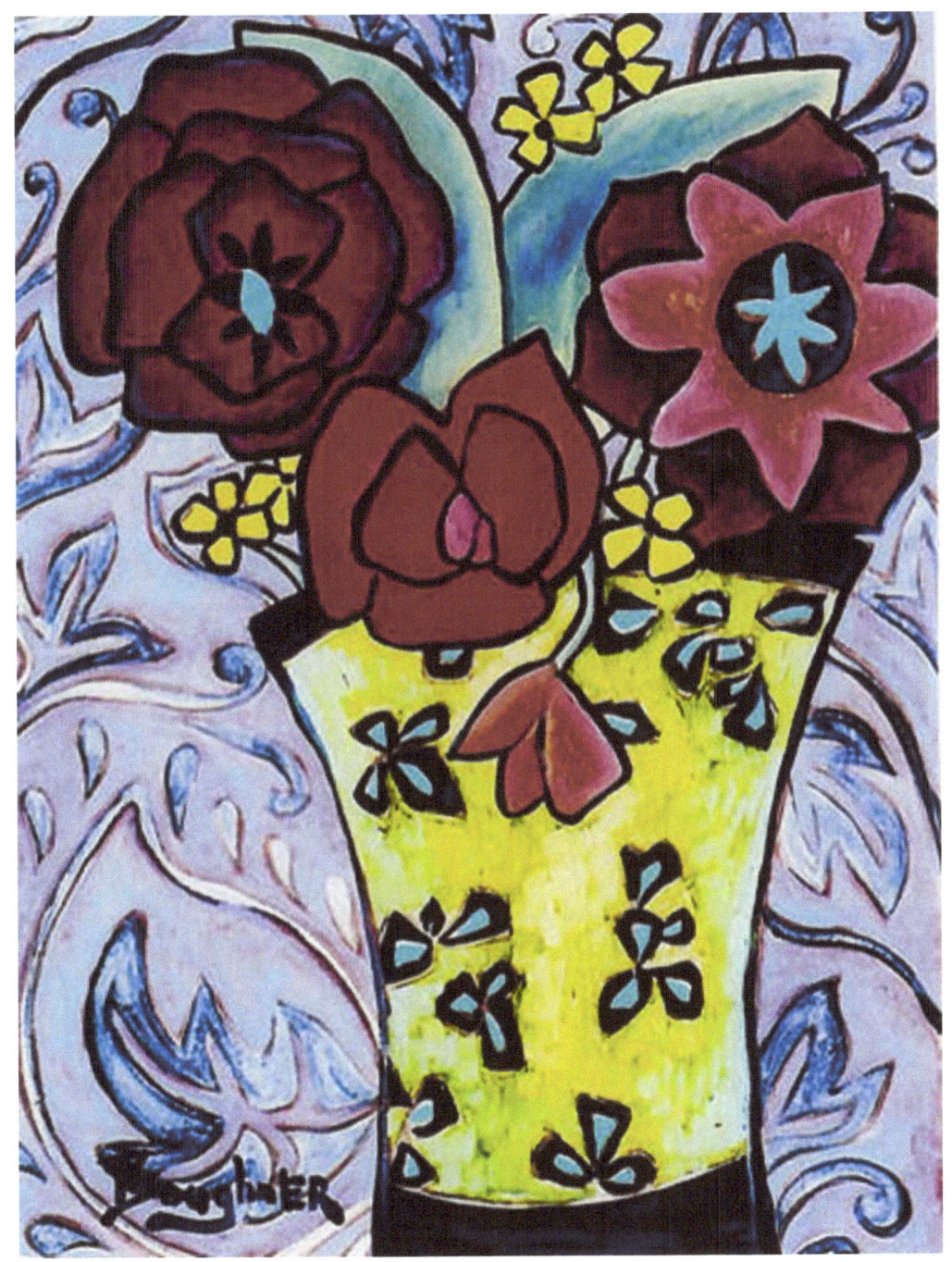

Lay Beside You

To be with you.

To peacefully lay beside you.

To brave each day's new adventure.

To grow old together,

Side by side,

With you.

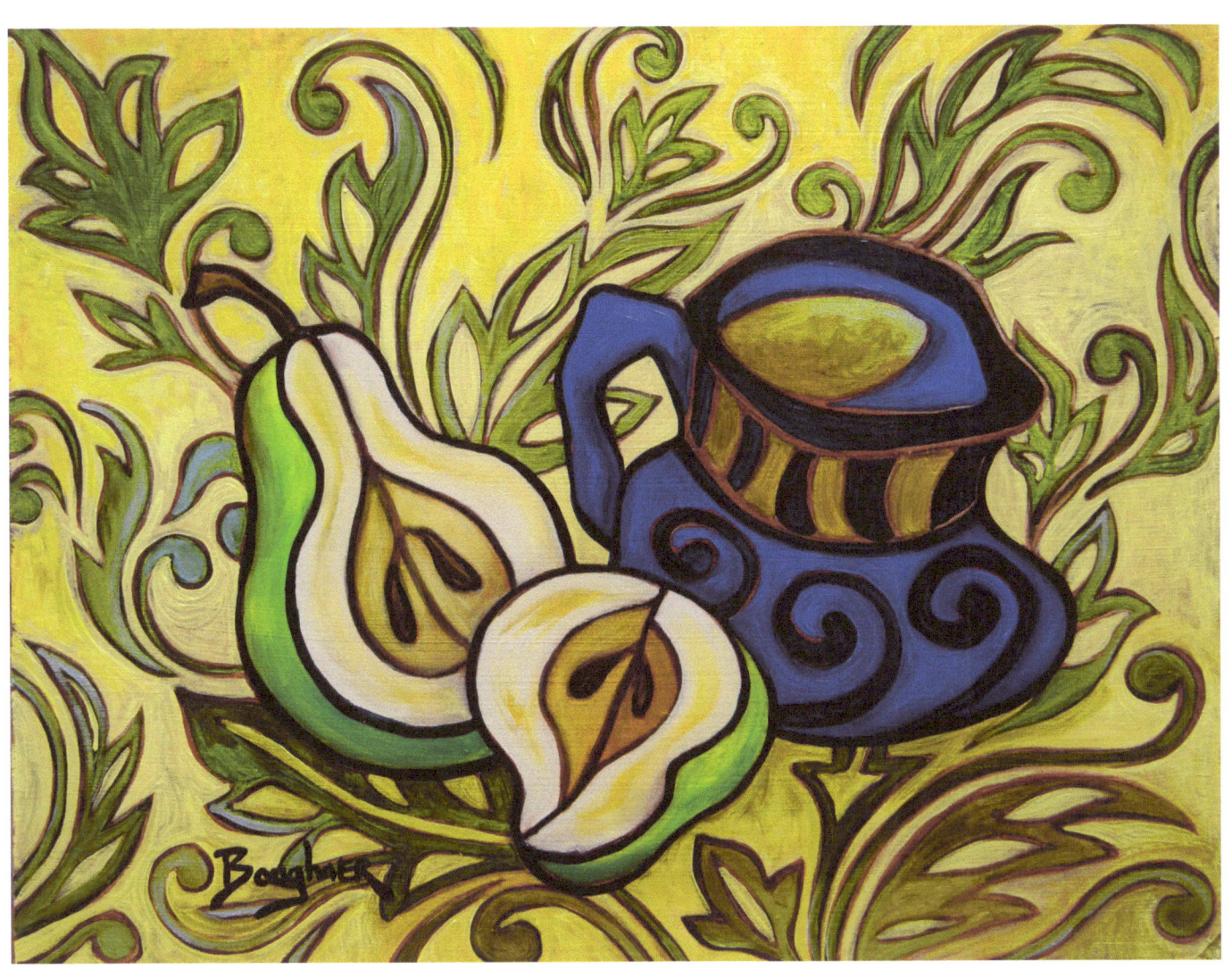

From Father to Son

He smoothes the old coat on it's hanger.

Lovingly caressing the worn fabric.

His mind wanders back to other times, as his fingers pass over patches of different fabrics,

alterations made to the coat over his years of possession.

He glances over his shoulder.

Studying the still figure in the bed. It's eyes closed in peace.

How sad for the loved ones left behind.

How joyous a future for him.

He thinks of his son, who's coat this is now.

At first it will be too big, as it once was for him.

Yet he knows his boy will fill it out, making alterations along the way and mending a few rips.

The coat is in good hands, with one look back, he turns to go.

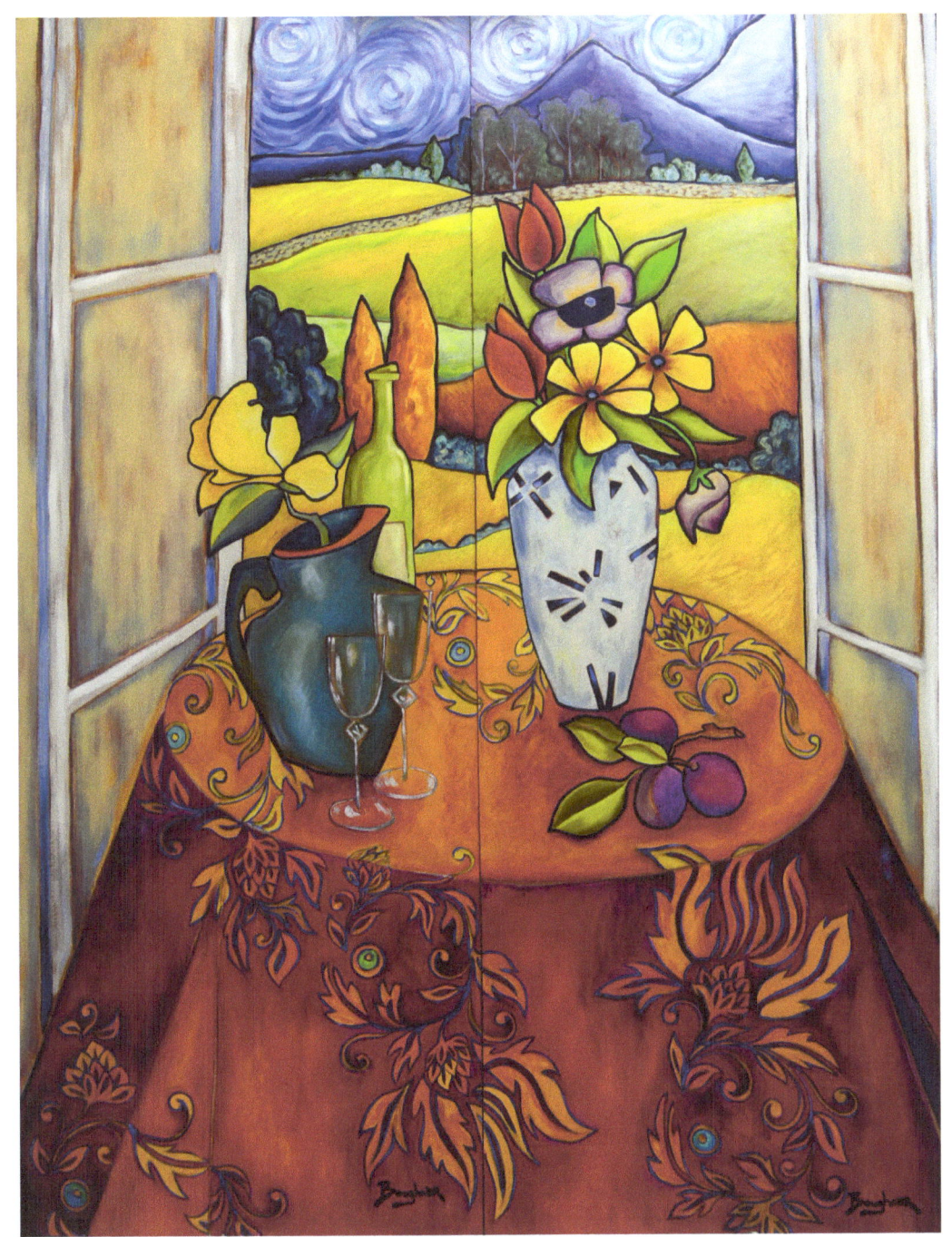

Breeze of Time

The drape wrapped so softly just the day before.

The permanence of a thought, ever fleeting and undefined.

Caught in the breeze of time, to be blown first one way and then another.

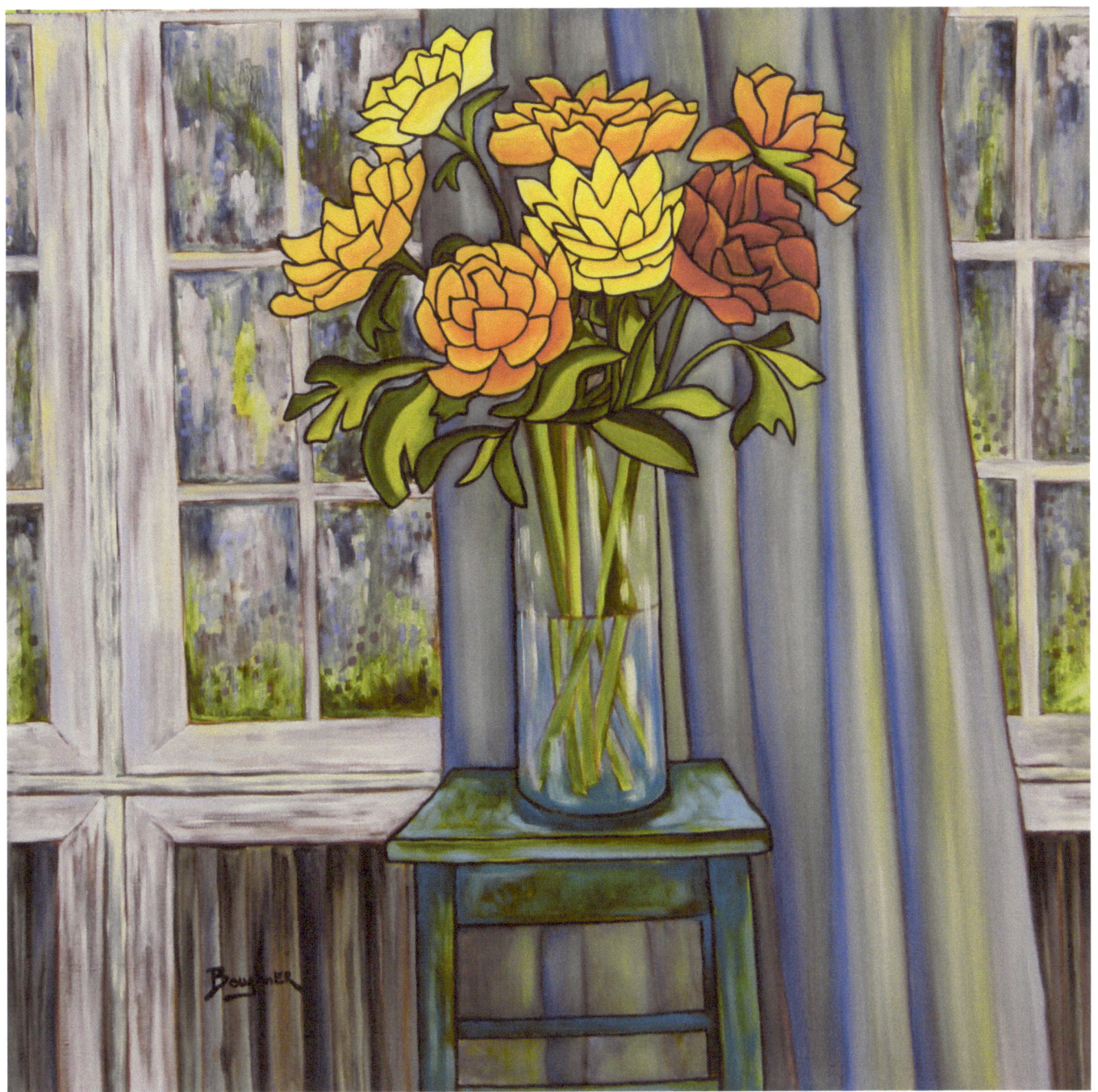

Right Where He Wants To Be

The daydreamer,

wondering what is over that next hill

or down the next block

or around the next corner.

Not thinking about the row houses that are actually over that very hill,

or the 24 hour mini mart that is down the block

or the gas station which is actually around the next corner.

No, the daydreamer sees a castle on that far hill,

a forest down the next block and

a herd of wild horses running free around the next corner.

The daydreamer in the castle is dreaming of a modern home of warmth and comfort.

The hunter in the forest is dreaming of a place of plenty where he can pick out his food with ease.

The wild stallion at the head of the herd…

is thinking he is right where he wants to be.

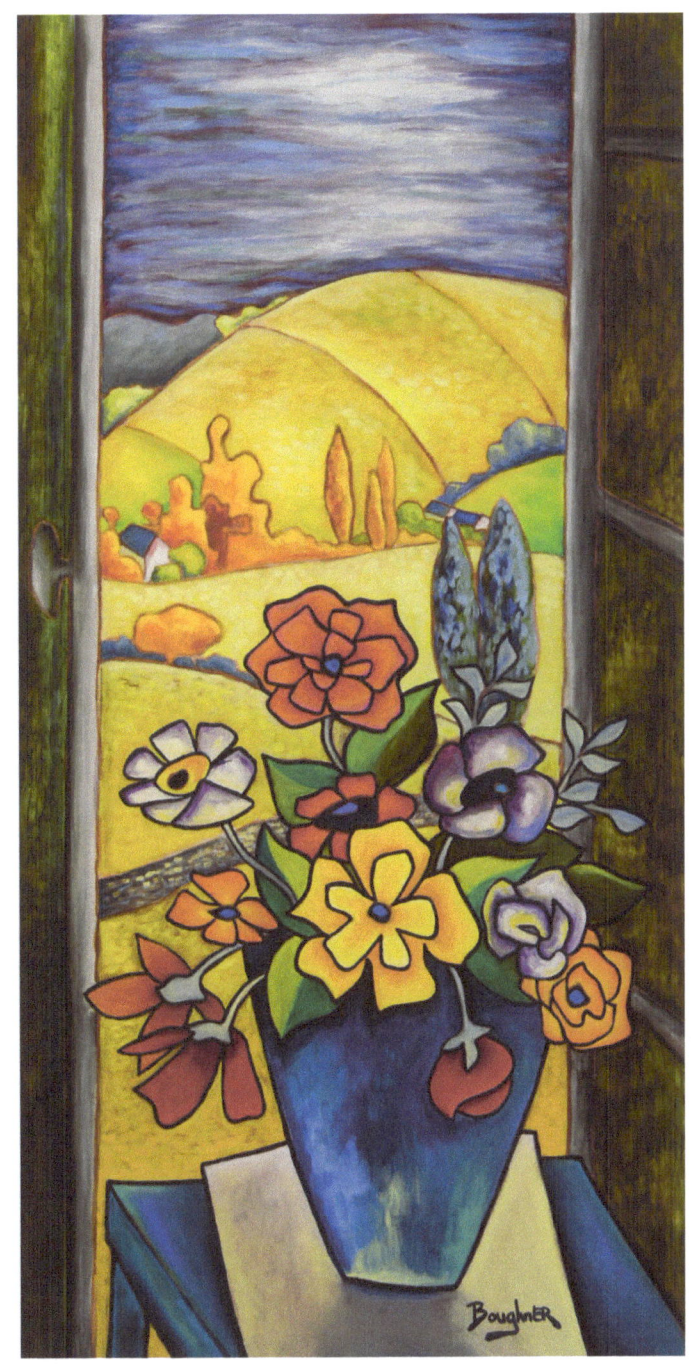

The Head of a Pin

The universe sits on the head of a pin.

Or perhaps it resides in the dark of the shadows, all around us but always unseen.

Or perhaps the universe resides in a bowl full of peas,

swimming around one another as if pulled from within.

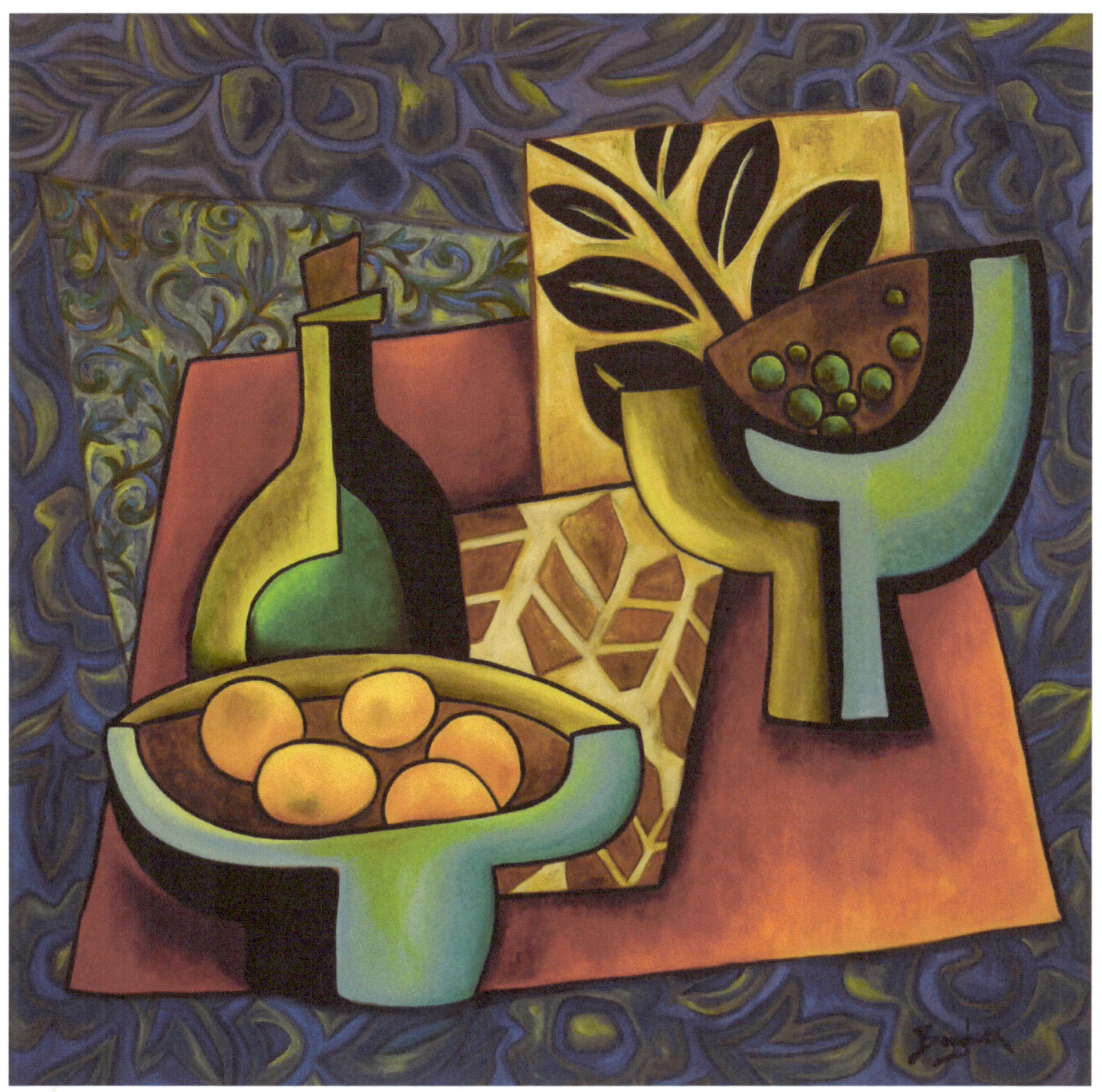

Different Opinion

The conversation changed so drastically.

We went from debate, to disagreement to words of hurtful anger.

We two, pushing away from the table as one, storming off in different but divergent directions.

I regretted my words even before they left my mouth, but pride refused to let me back down.

I respect your opinion and your words of wisdom more than you will ever know,

even if I do not always agree with them.

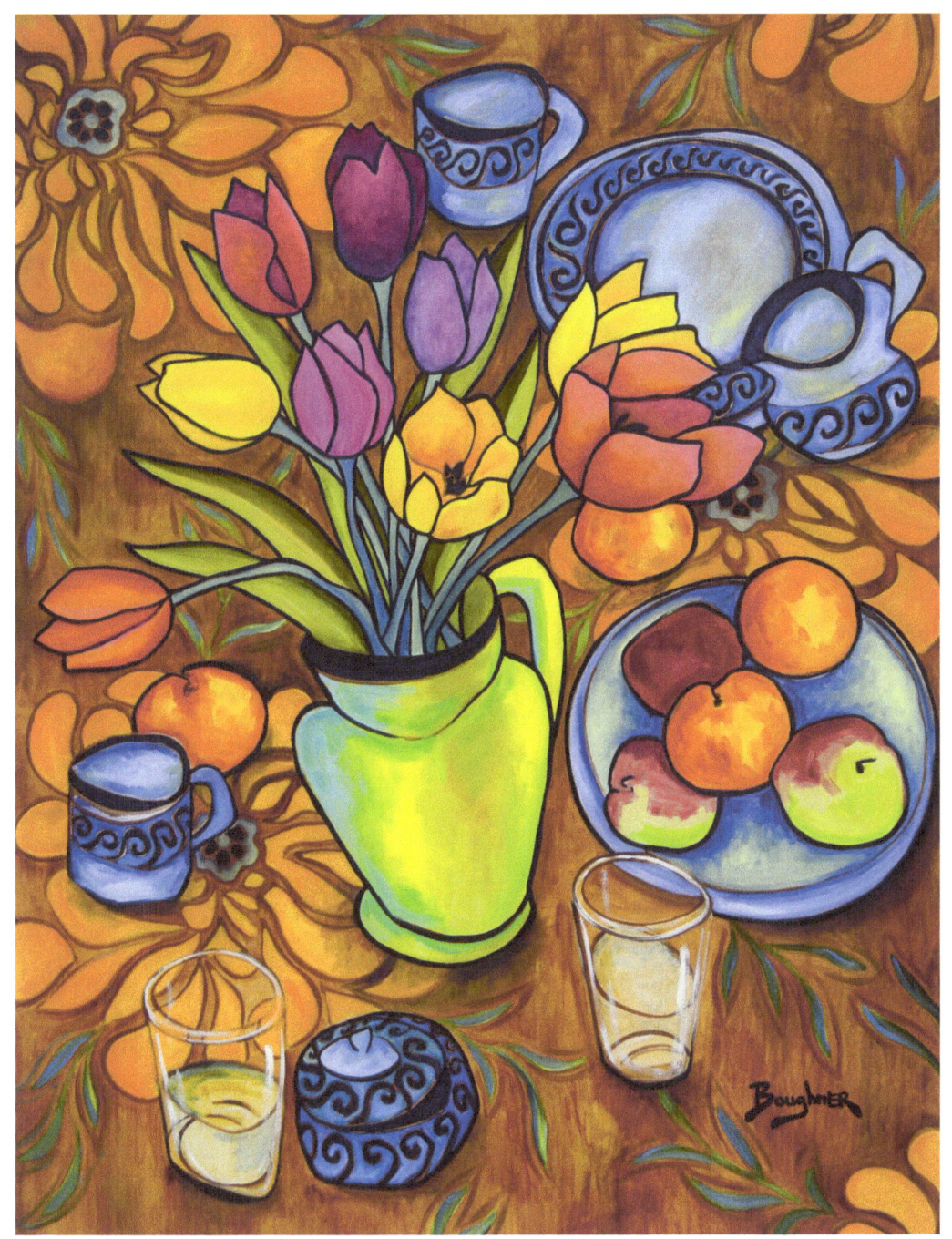

Knowledge Within

Upon meeting we shake hands.

Point of fact, it is he who takes control and shakes my hand.

I am engulfed in his grip, a warmth seems to spread not only from his touch but from his very presence.

His hand feels like onion paper wrapped over a warm stone.

His grip is mighty yet reassuring.

He has come here seeking my help but I already feel as if I may need his.

What time must pass to create hands of such magnificent ancient beauty?

What knowledge has passed through them in the form of newsprint, letters or books?

His grip compels me to be helpful and mindful at the same time.

The hand shake is released as suddenly as it had begun.

I stand back for a moment and look at my hand,

his very being seems to dance around my fingers like smoke from a just extinguished candle.

I look from his hands to his eyes, questions dancing around the fringes of my mind.

But then the moment is gone, all that is left is business.

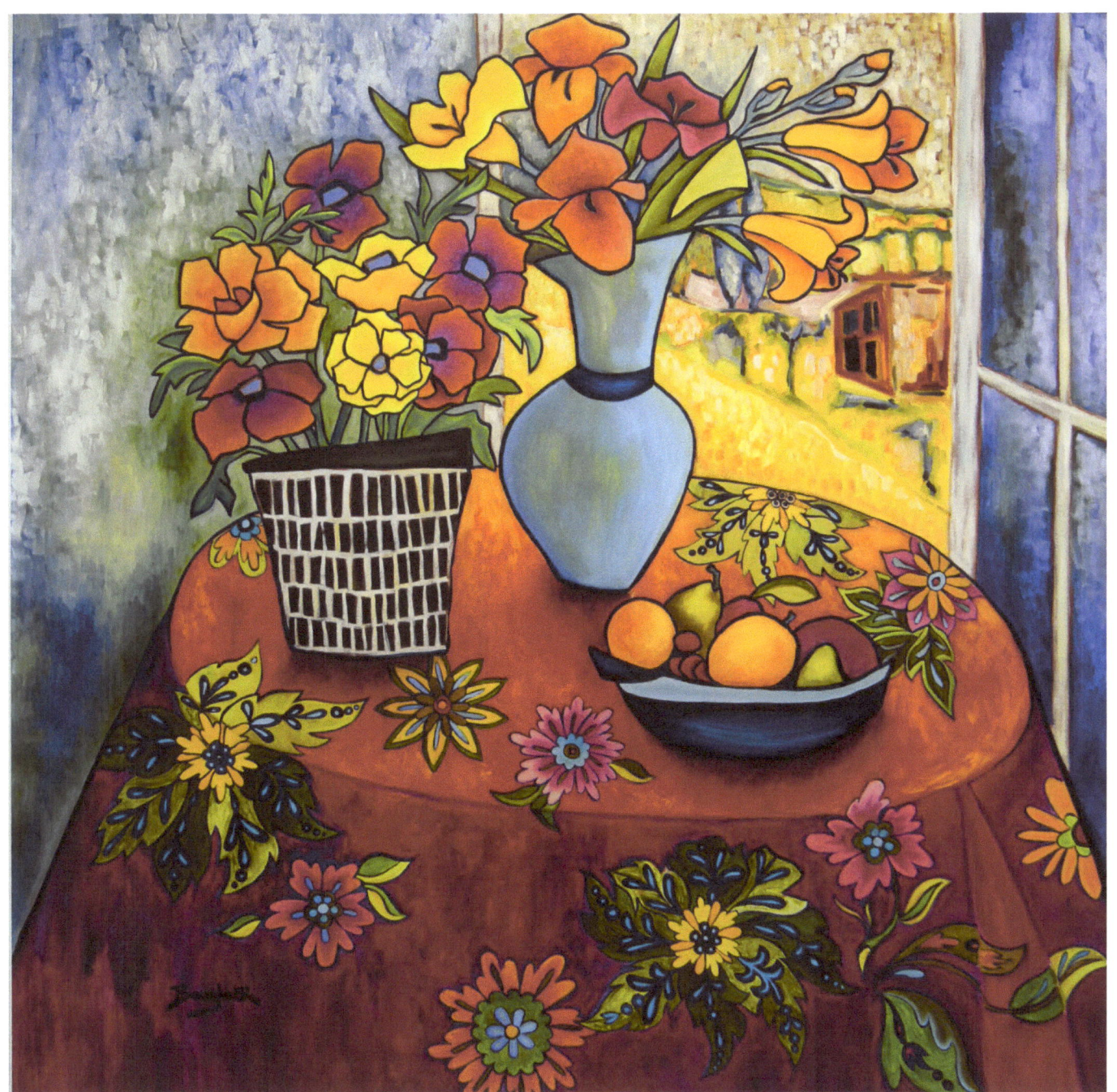

Bold Realization

The bold and the unconventional.

To be at once here but altogether gone.

To be in the present without truly being here at all.

The bold realization that we are here one moment and gone the next.

To live in the color and the abstract of our very own lives.

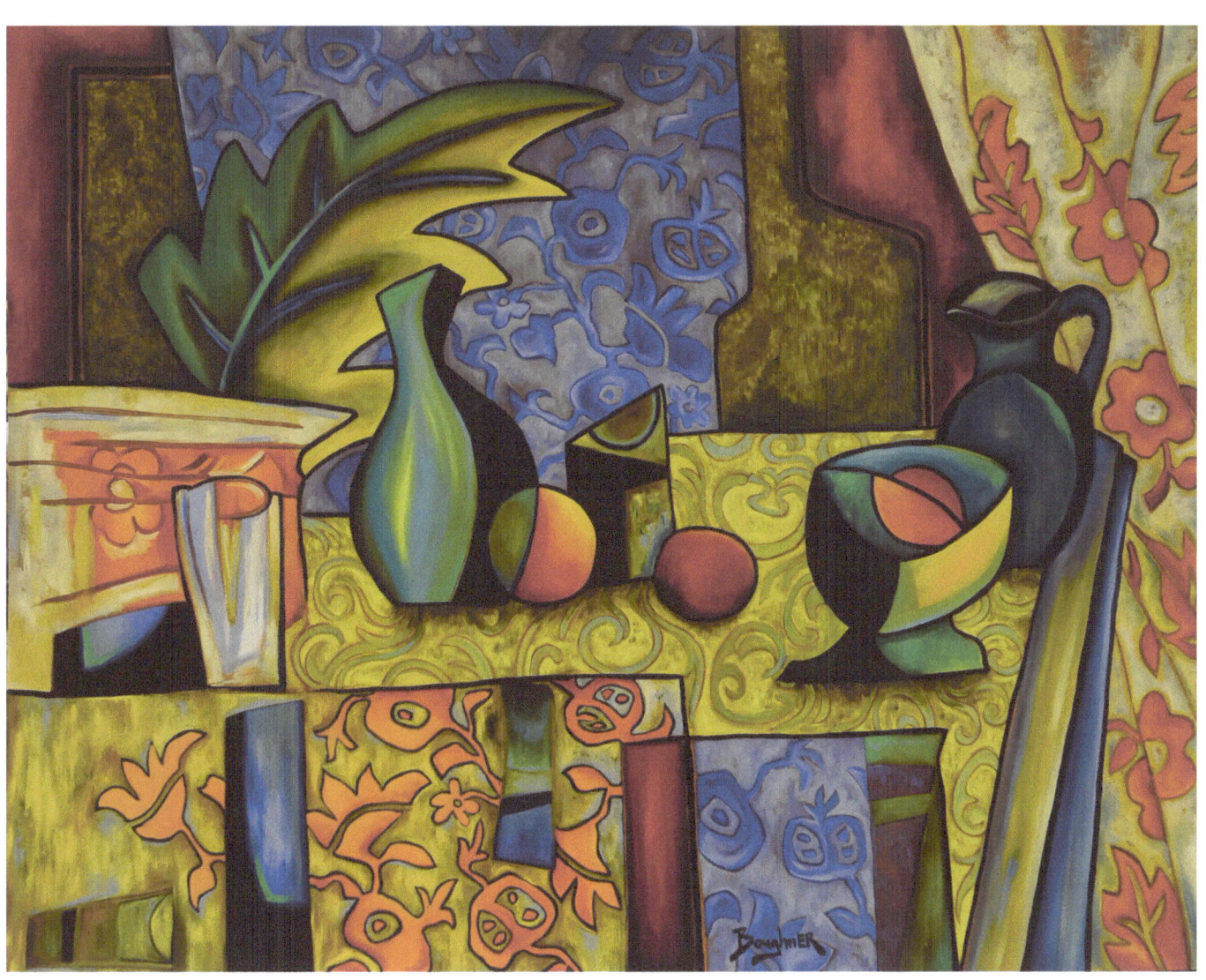

Where Peacocks Go For Tea

There is a place in a land some may not know, where the Peacocks all gather, just around three.

They all gather for afternoon tea.

They come from the country and the city alike, all for a chance to gather and be.

Just to be plain old Harry, Clara, Suzy, you or me.

They compare tails both large and small, they compete to see whose tail is grandest of all.

Then as quickly as they come they all go, back to the daily life that all of us know.

Flexing their tails and amazing us all until tomorrow comes,

when they can stop again for tea just around three.

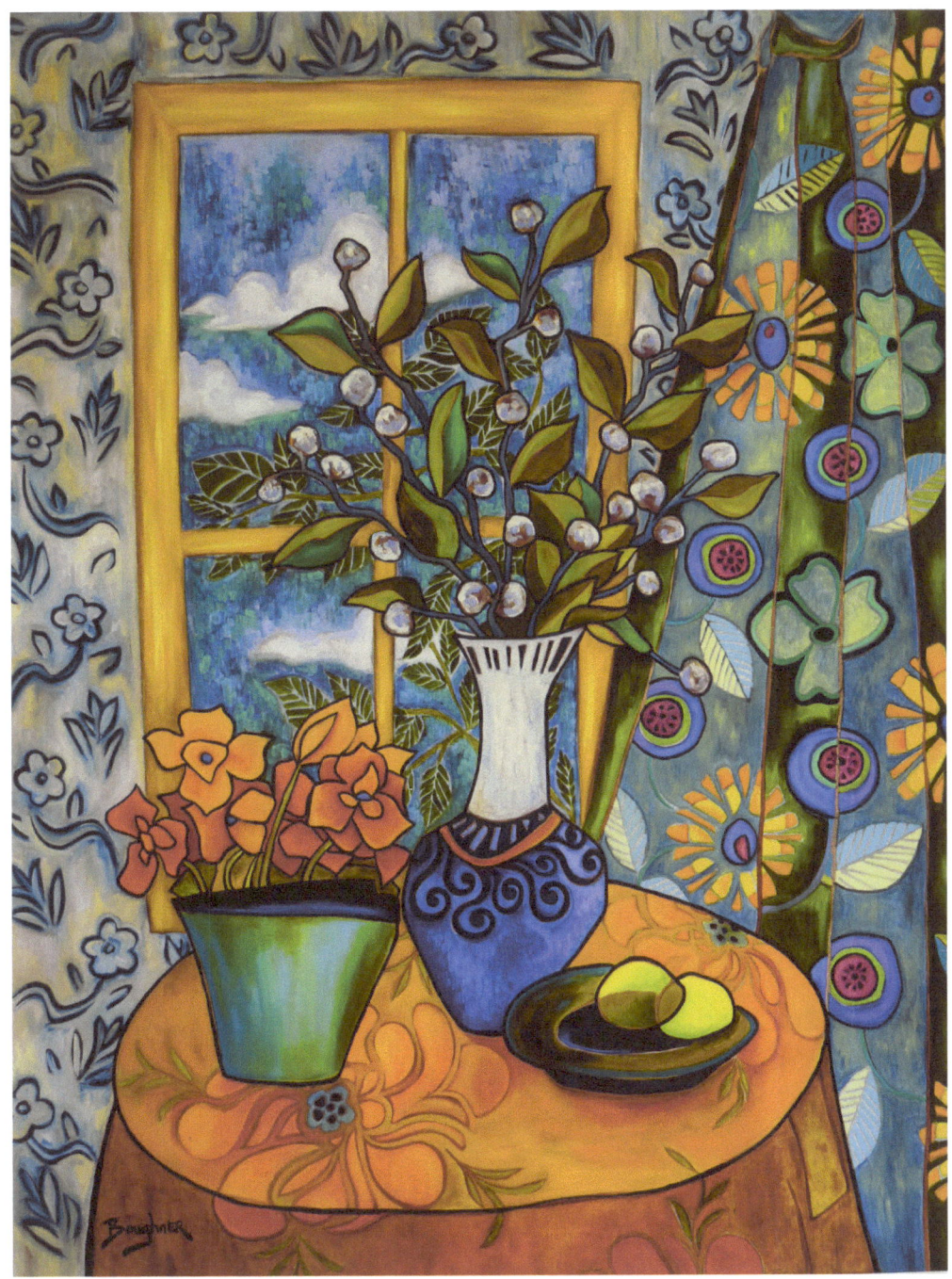

Sensuous Fruit

You have to admit it.

You have to accept the peach is a sensuous fruit.

Its color is the very sunset turned to solid life.

Its curves can be seen as a beauty from behind or the blushing hills of desire.

Its skin is the soft lovers caress, its taste the sweet lingering kiss of a lover.

Come now, admit it, you have never given this particular fruit it's just deserts!

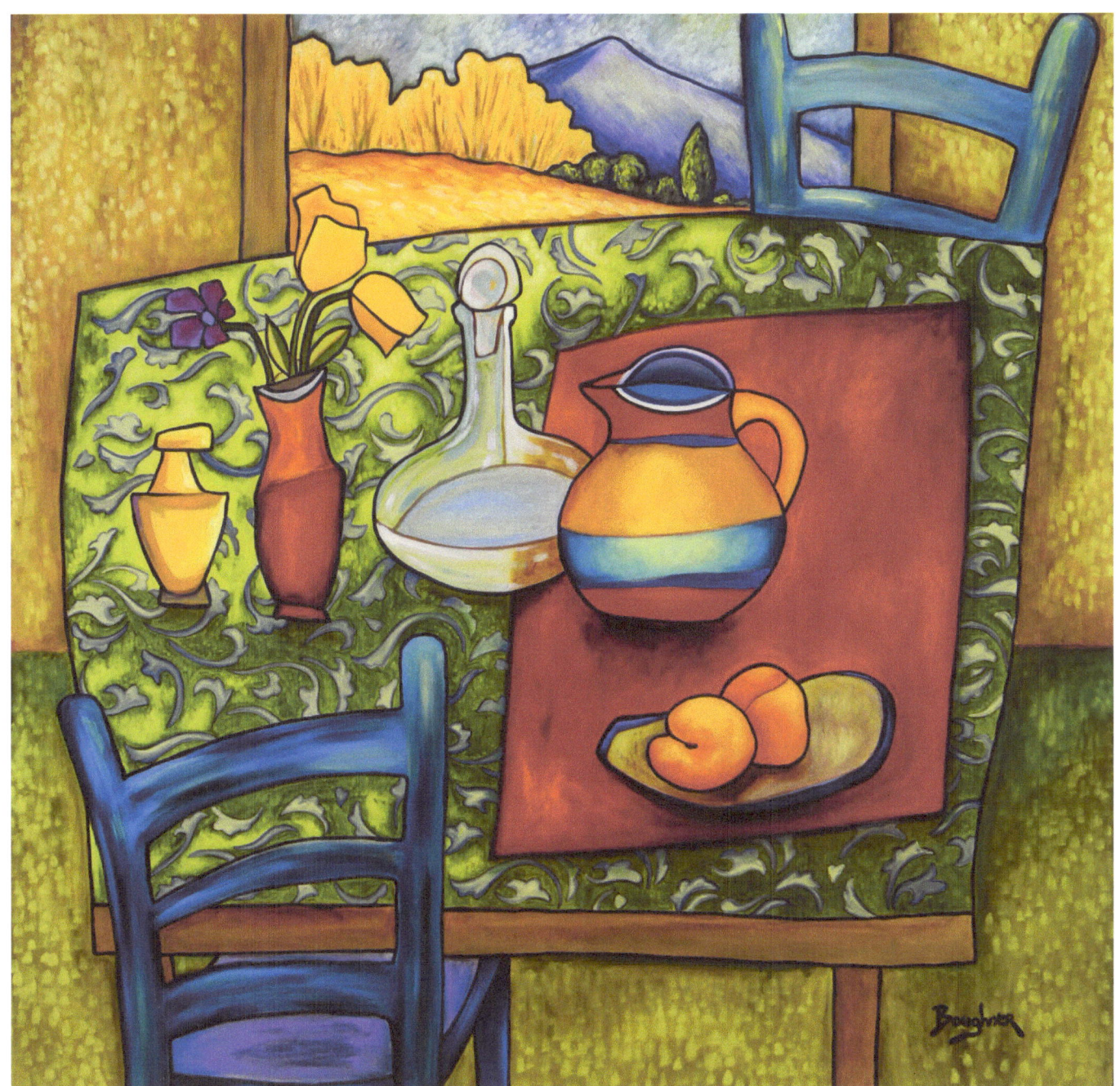

Confidence of an Ant

To have the confidence and the determination of an ant!

That's right, I said an ant!

A creature so small as to be over looked by most.

Yet one so driven that it can move a mountain from one side of the sidewalk to the other.

One grain of sand at a time.

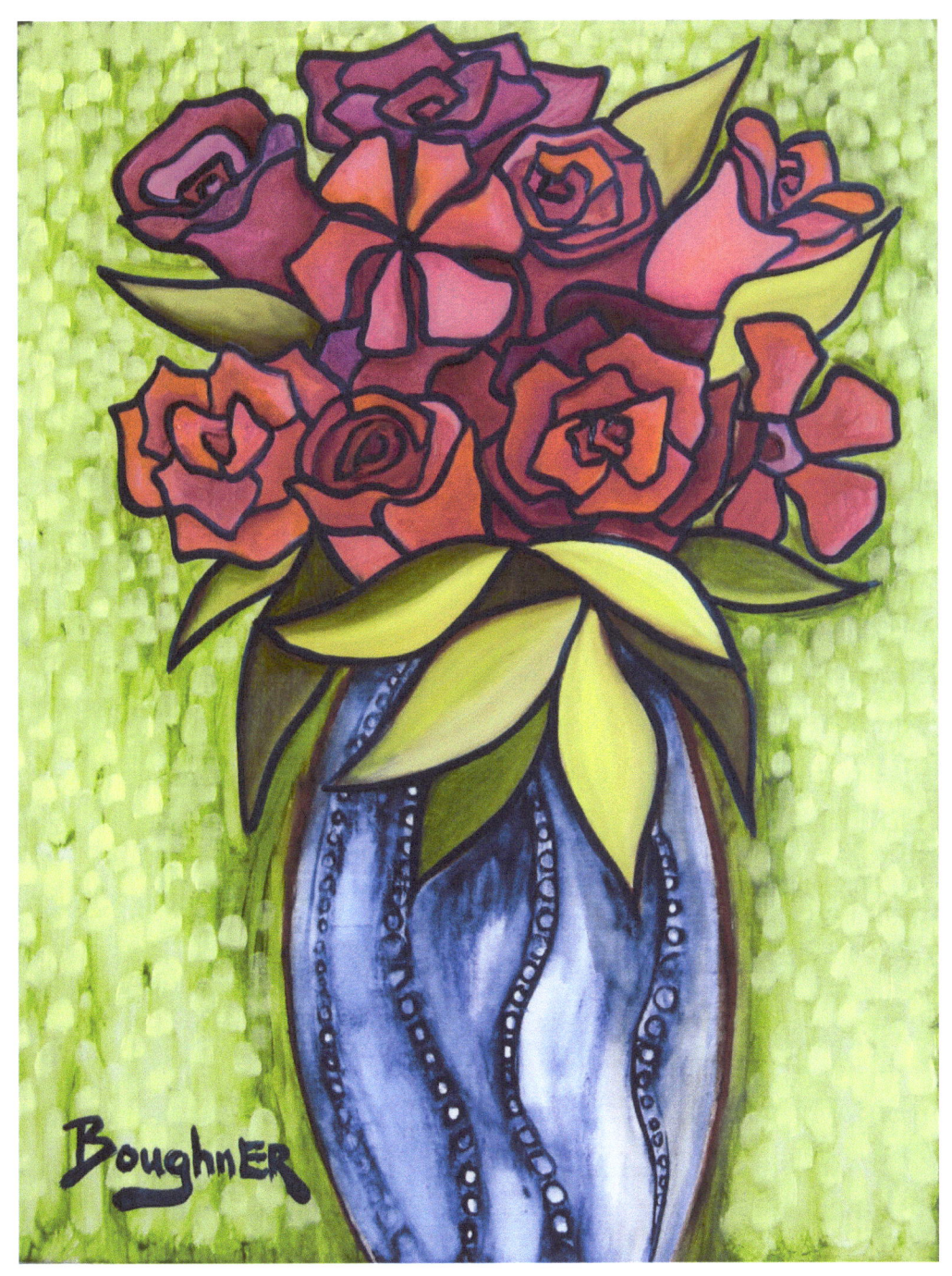

Bindings of Each Book

When was the last time you really looked at a book shelf?

Really noticed the books lined up in marching order, one after another.

The different colors, thicknesses, textures, design, and even age.

Now try to imagine what gems lie beneath each cover.

What knowledge, joy, laughter or pain each binding holds.

Now, take a good look at the world around you.

When was the last time you gave a person a chance to reveal the depth of knowledge that each and every one of us contains?

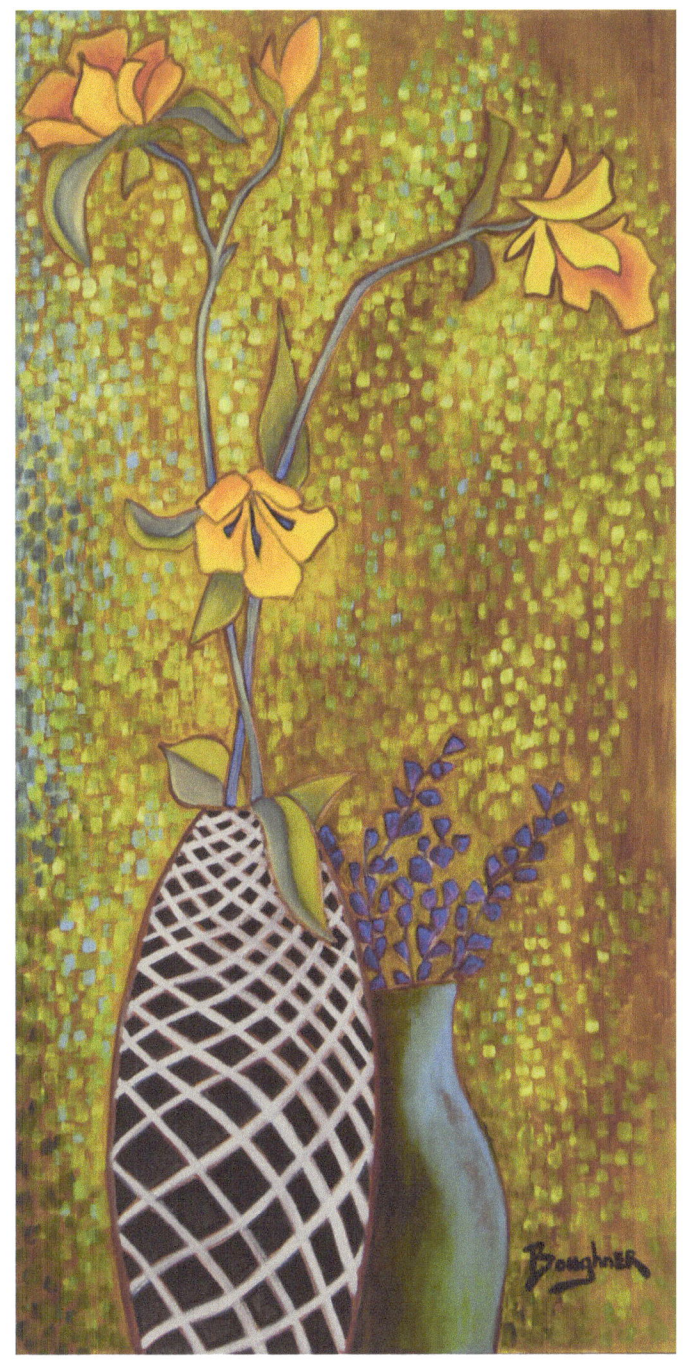

Willowy Cloud

Only yesterday you were standing right there.

Yet today I can only catch a shadowy glimpse of you from the corner of my eye.

The spirit of your presence haunts me like a willowy cloud drifting from room to lonely room.

Sometimes there, but blown to nothing in the wink of an eye.

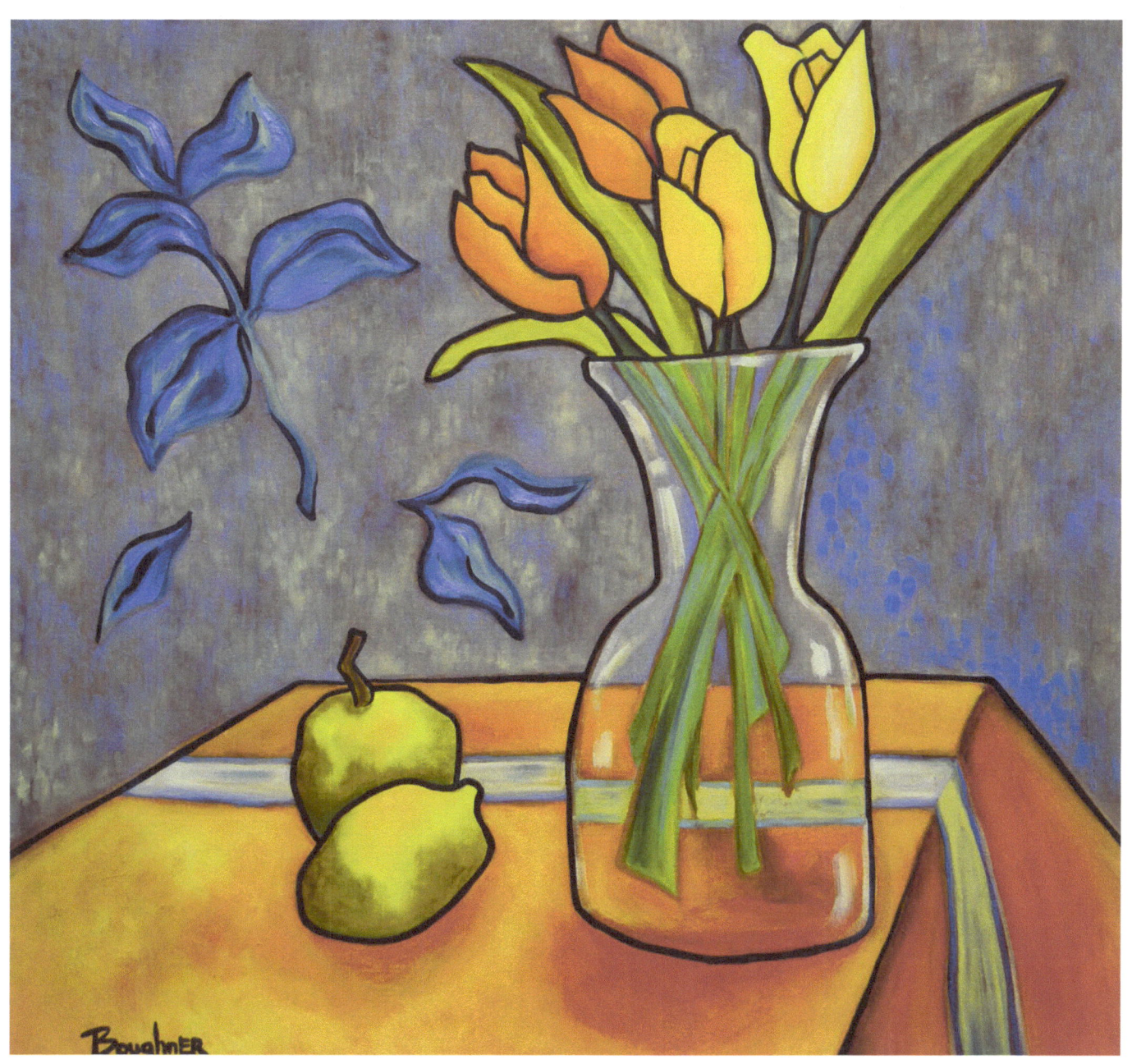

While Away

Confusion swirls around me.

One dashes this way, one jumping up while another is jumping down.

How do I control such energy?

How do I tell them of the chaos in their actions?

How indeed.

Instead I choose to contain the exuberance, keep them safe while they while away the day.

Safe, supported but never to be controlled.

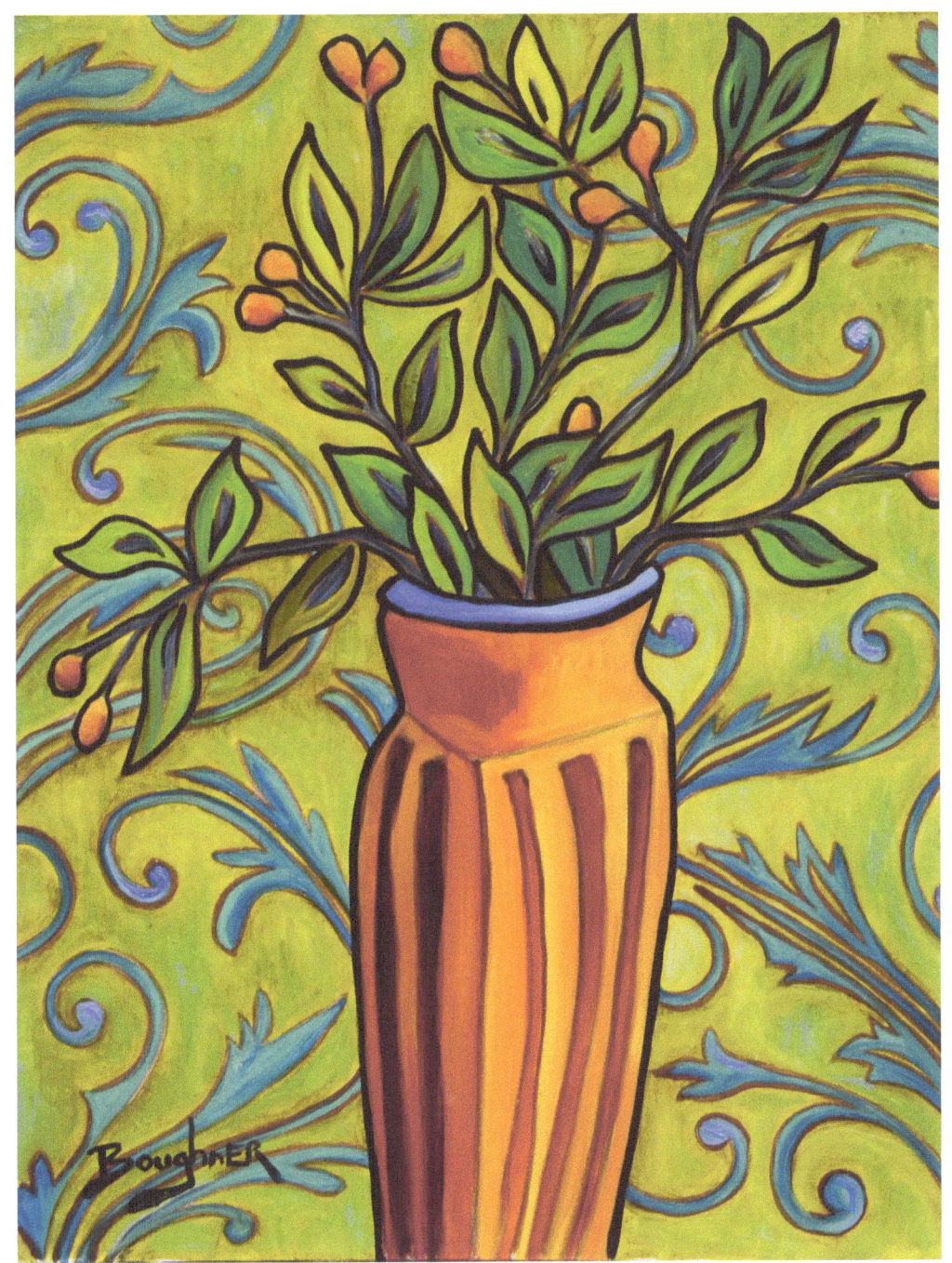

Draw Us Ever Closer

To be together but oh so different.

The same form and function but with such different flare.

We stand apart but are so much stronger together.

Our differences are what draw us ever closer.

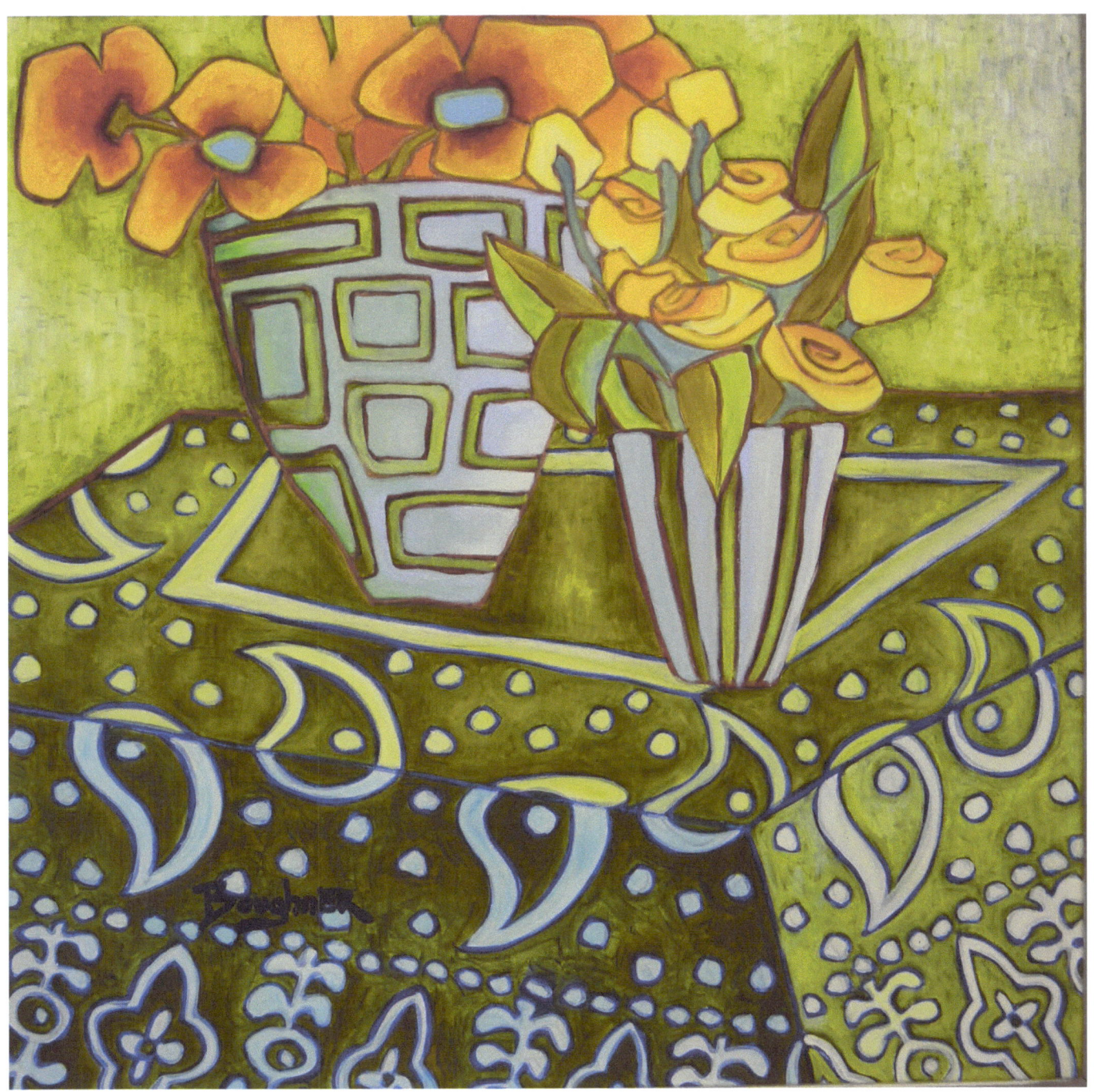

Concentration

The stark look of concentration on his face, so severe as to startle a casual observer.

He attacks his work again and again.

Sending chips flying where they may.

His finished product rests in the inner form of the stone.

Locked in his imagination.

A road only he can travel.

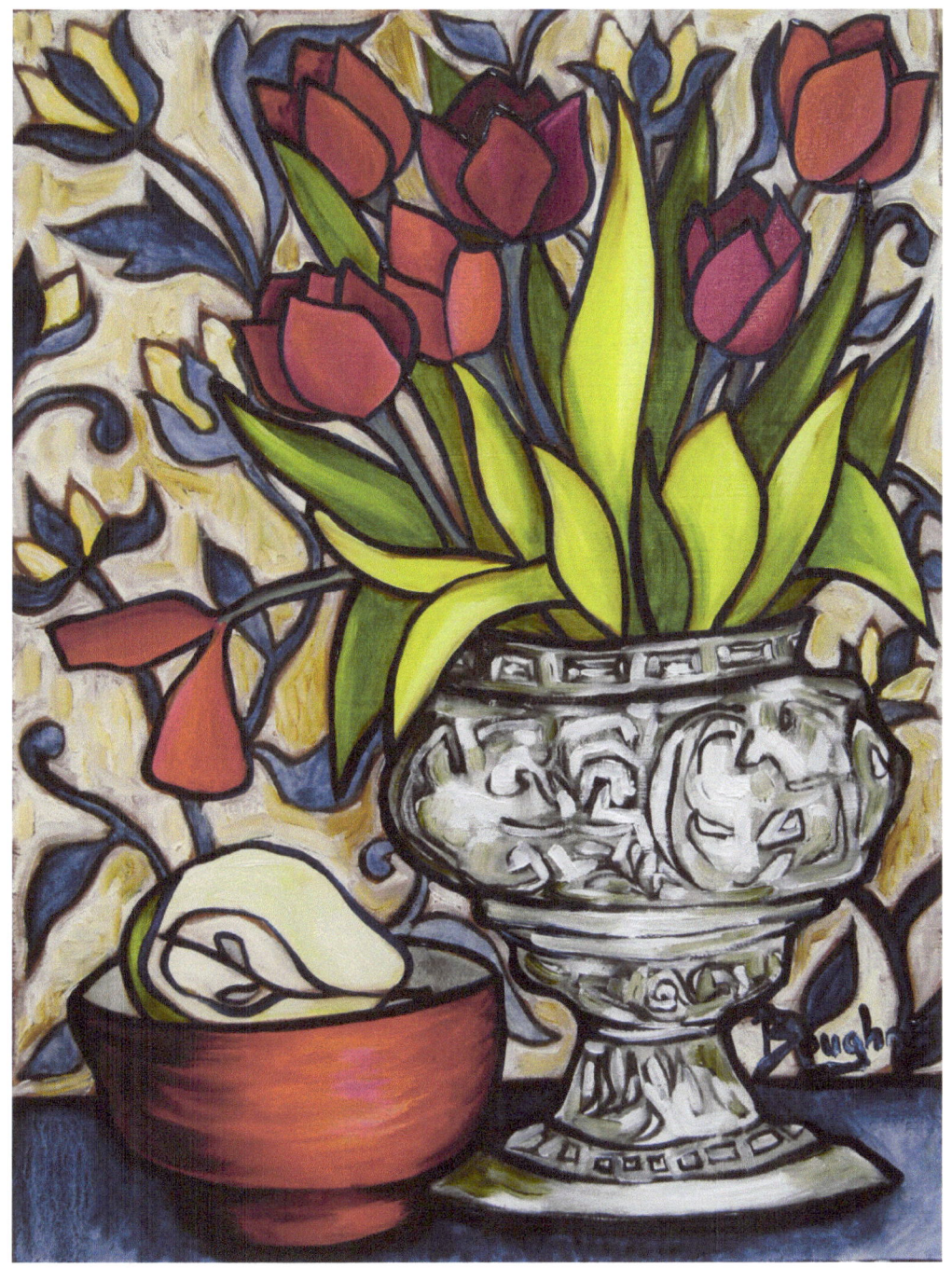

Three Oddities

We three oddities.

We make good conversation, we make good fodder.

But what if we do not want to be the center of discussion?

What if we want to sit peacefully in the corner of the Den, whispering our sweet secrets and sipping our tea?

What if we three choose not to be what you have chosen us to be?

But instead to be ourselves, bold and beautiful and independent of what others may think of us.

 We three will have none of it, well,

maybe just me.

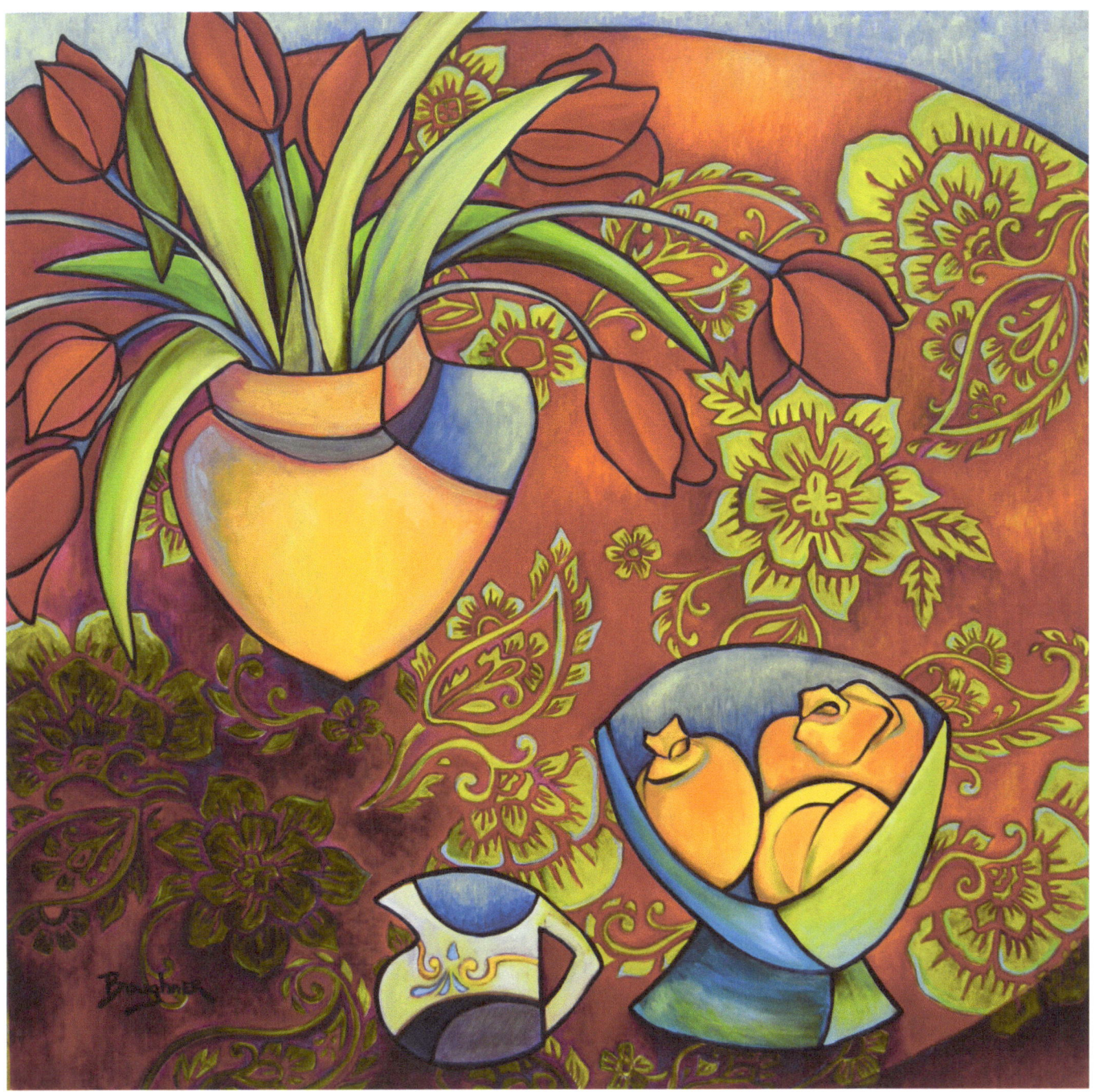

Light of Your Attention

Once left to ripen in the light of your attention,

now left to rot in the distain of your indifference.

I sit alone in my misery wondering what I have done to bring about such a

tragic change in the way you look at me.

I look up as you enter the room; gliding across the floor,

I marvel at your grace, your confidence, and your beauty.

You do not even acknowledge my existence and move on once more.

I turn to the window, no light is there to brighten my demeanor,

just foggy rain and moonshine to deepen my mood.

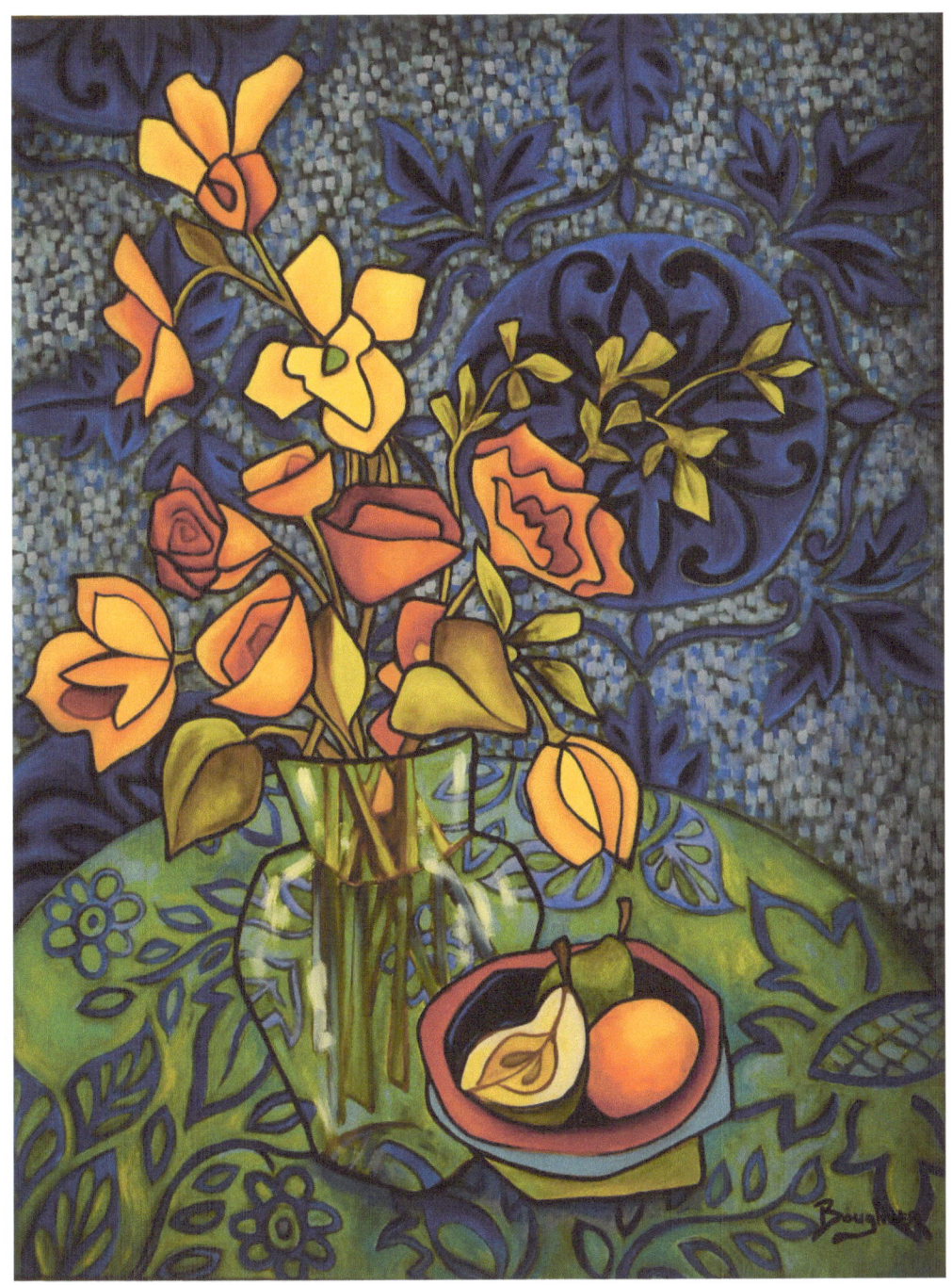

ABOUT THE AUTHOR

Martin R. Boughner has been immersed in art since his
Uncle Charlie took him on his first photo safari in the wilds of Chicago!
He still has that beaten up old Nikon and the photos from that day.
Martin went on to develop more and more images, always in black and white.
The spot of color in his life came in High School when a beautiful young girl asked him to a dance.
34 years later and he is still enjoying photography, writing and
the art of that beautiful young girl who is still putting up with him even after all that time.

More of Elisa R. Boughner's artwork can be seen on her website:

www.BoughnerArt.com

www.ingramcontent.com/pod-product-compliance
Lightning Source LLC
Chambersburg PA
CBHW050900180526
45159CB00007B/2743